59 Rodney Str

Home and studio of
photographer Edward Chambré Hardman

Liverpool

THE NATIONAL TRUST

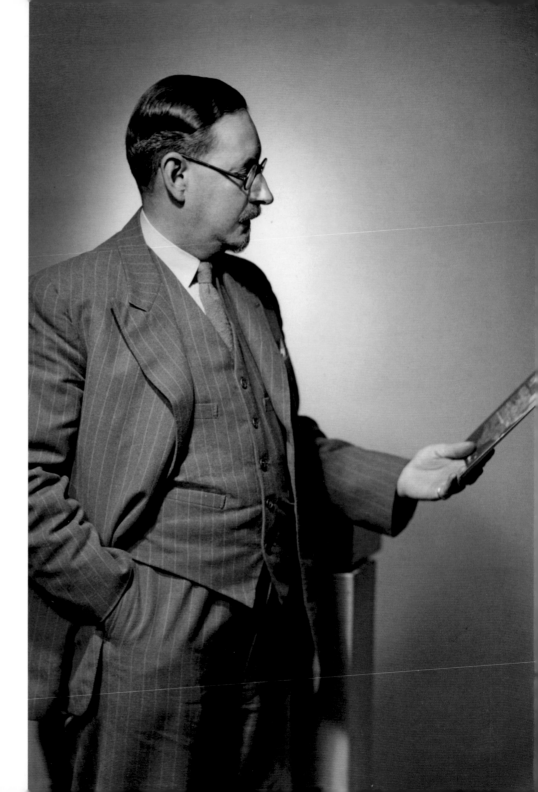

Top Margaret Hardman with the studio camera at Ritchie's photographic studio in Paisley, where she worked in the 1920s (140033)

2

SITTING FOR POSTERITY

Today, digital photography is commonplace, and the idea of taking and developing a photograph without a computer, let alone visiting a studio to have your picture taken, is becoming more remote. However, it was only a few decades ago that Edward Chambré Hardman and his wife Margaret ran a prosperous and extremely active business, taking portrait photographs and exhibiting their landscape photography.

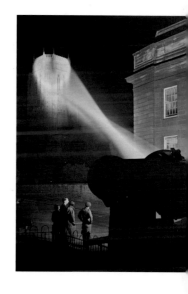

Marking time

In the 20th century, anyone who could afford to would have a professional portrait photograph taken in a studio to mark rites of passage: a christening or a 21st birthday, a graduation or a wedding. Two world wars galvanised those facing the prospect of death, so they would sit for a photograph, as a memento for their loved ones.

The Hardmans

Chambré Hardman developed an interest in photography as a child, but he decided to make it his profession only when he went into partnership with his friend Kenneth Burrell. In 1922 he settled in the prosperous city of Liverpool, where his reputation as a photographer of distinction grew, as did his passion for the subject. Whilst the portrait business prospered, he also managed to travel widely, taking landscape photographs which he exhibited at the London Salon of Photography. He fell in love with Margaret Mills, who worked for him from 1926, and after a long, interrupted courtship they married in 1932. In 1949 they moved to 59 Rodney Street where they lived and worked together for the rest of their lives.

The House

59 Rodney Street is the only known British photographic studio of the mid-20th century where the photographer's entire output has been preserved intact. The photographic practice with all the necessary technical equipment, the business records and public rooms, together with the chaotic private quarters, can all be seen beside the wonderful photographic images.

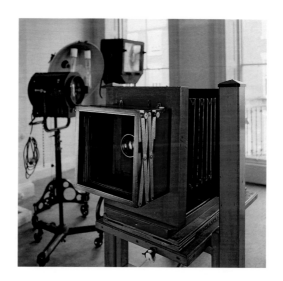

Above The tower of Liverpool's Anglican cathedral illuminated by a searchlight for the 1951 Festival of Britain (110175)

Left Chambré Hardman's camera and lights in the Studio

Opposite Hardman photographed by his wife Margaret (140001)

TOUR OF THE HOUSE

Rodney Street is named after Admiral George Rodney, victor at the Battle of Les Saintes in 1782. Building work began the following year and continued for several decades. It has long been regarded as one of the most prestigious addresses in Liverpool. The street was occupied initially by merchants and increasingly, in the 19th century, by doctors and consultants. The Victorian prime minister W.E. Gladstone was born at No.62.

Right The front door of 59 Rodney Street

Opposite The Waiting Room

Having collected your ticket at the visitor reception on Pilgrim Street, please enter the property at the front door on Rodney Street.

The Entrance

59 Rodney Street has a handsome three-storey, three-bay, brick façade, which forms part of a larger symmetrical terrace. The simple sash-windows are taller on the first floor to allow more light into the original drawing room. A short flight of steps leads to the front door, which is flanked by Doric columns, supporting a plain frieze. Engraved business plates adorn the columns and front door, and a metal bracket overhead supports an unusual basket of flowers, which was added by Chambré Hardman, providing a landmark to guide you to his premises.

This was the main entrance for visitors

or clients, who would have been let in by the receptionist or another member of staff, having made an appointment. They were then shown to the Waiting Room.

The Changing Room

Today, this is where you can see a short introductory video explaining Chambré Hardman's life and work. The room's original function was as a changing room. In preparation for their photograph, sitters could change into their chosen clothes, such as an army uniform, mayoral robes or wedding dress. A full-length oval mirror, coat and hat stand, sofa and desk were provided to help them prepare and to make them feel comfortable.

The Waiting Room

The Waiting Room was the smartest interior in the house, designed to give a good first impression of the business. In this room, as a client, you could view samples of Hardman's work, a selection of print sizes, mounts, frames and a price list. Staff recall how this room had a sense of opulence and calm. It is furnished with mahogany pieces, an Indian rice cooker (brought back by Chambré Hardman from his time in the Indian Army) and a Tiffany lamp. After Chambré Hardman retired, he used this as his main living room.

From here please walk up the first flight of stairs, turn right and up the short flight of stairs and forward into the Studio on the first floor at the front of the house.

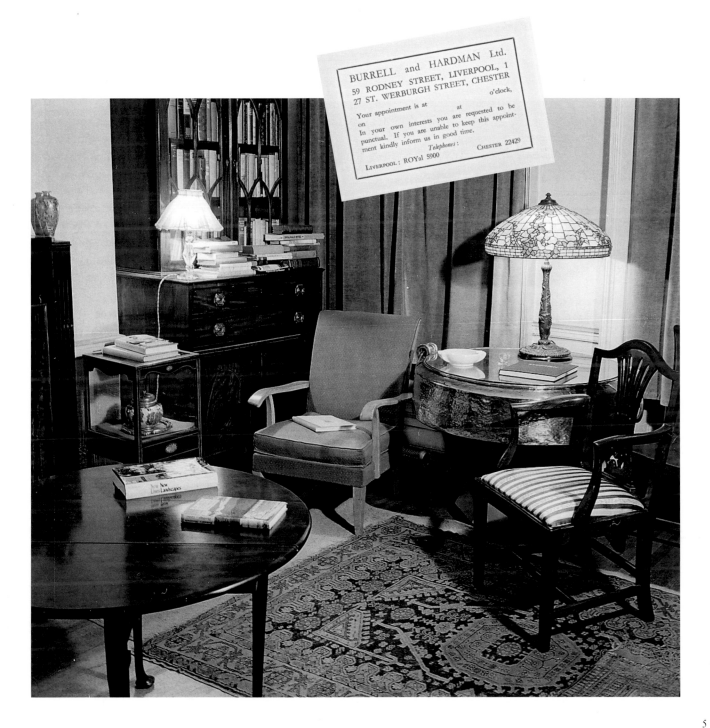

The Barnston Dark Room

This was the Hardmans' personal developing room, named after the village in Cheshire where they lived before moving to Rodney Street. In the darkened room, negatives and prints could be developed, enlarged and retouched. The lead sink, bottles of chemicals and enlarging equipment can be seen. Staff recall that Chambré Hardman would play his favourite music (as you will hear) whilst working.

Return down the stairs to the Exhibition Room.

The Exhibition Room

Here are displayed a selection of Chambré Hardman's original prints and some of his equipment. In Hardman's time it was used to store extra equipment that might be needed in the Studio.

Please go down the stairs to the landing and turn right up a small flight of stairs to the next suite of rooms.

Top The Studio photographed by Chambré Hardman with the Ionic plinth he used as a prop (140031)

Right Hardman kept a box of toys to relax his younger sitters

The Studio

The drawing room of the original Georgian house, this is the largest and best–proportioned room in the building, well lit by three large windows. This is the room where clients would come and have their photograph taken. A backdrop, with some props, is prepared for your sitting, and toys are at hand to amuse younger sitters. A bank of lights, cameras, tripods and technical equipment face the stage poised and ready. Hardman would take time to ensure the lighting was right and the sitter at ease.

Leave the Studio and head up the stairs to the top floor.

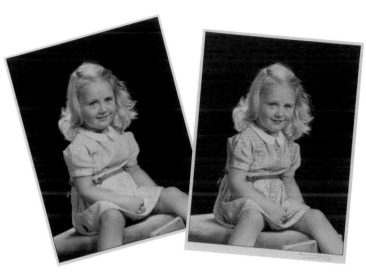

MAKING A PORTRAIT

Chambré Hardman achieved the quality and artistry he was known for by taking a lot of trouble. He knew how important it was to 'find out about the sitter, talk to him; on arrival he would be tense – not a good time to take a photo. I would spend time putting them at ease, talk and find a common bond of sympathy or interest.' He would carefully adjust the lighting and composition and take several negatives, chatting away so that the sitter was not conscious of the process. A sitting could take an hour on average. He later recalled that winning over a shy person, by getting to know them and bringing out their personality to produce a successful picture could be more rewarding than achieving the same result with a self-confident individual.

The studio session was only the start of the process. Each morning the staff would begin by making up the chemicals needed for the day. They would then develop the negatives in a darkened room with a red or yellow light; some staff recall spending all day in the dark room. To improve the image, they would shade some areas with a card and lengthen the exposure for others. A coded note recorded the method applied in each case so that it could be repeated. Staff produced a number of proofs from which the Hardmans would choose the finished print.

Once approved, it would be mounted using a gas-heated press, packaged in a beautifully presented folder, embellished with the firm's monogram, and dispatched. Each chosen negative and print was numbered together, and a card also numbered and filed, often with notes about eye colour, a lock of hair or a piece of clothing fabric to help with accurate colour tinting, if required.

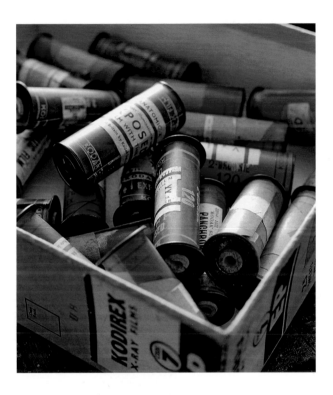

Top left Mrs J. Green's daughter, 1952. A portrait before and after tinting (120212, 120211)

Above The large-format roll film Hardman used for his portrait work

Left The Barnston Dark Room

7

THE LIVING QUARTERS

Margaret is said to have joked: 'What do Scotland and our Kitchen have in common? – Both have Islands of Muck.'

In contrast to the public and working areas of the house, which were kept meticulously clean and well-presented, the Hardmans' private quarters were a mess. They tended to continue working in their own time and space, and rarely, if ever, entertained guests in this part of the house. They preferred to eat on the hoof, or out with friends.

The Kitchen
The Kitchen is furnished with the original 1950s pieces, with cupboards full of packets, tins and post-war rations just as they were left by the Hardmans. The table is piled up with papers and photographs awaiting attention.

The Living Room
This served as a multi-purpose room and is densely furnished, probably with surplus items from their previous house. The Gordon Russell furniture is very stylish for the time, and the golf clubs are a reminder of Margaret's time in Scotland, where she would play golf regularly.

The Bedroom
Their small bedroom at the back of the house opens out on to the rear balcony overlooking the garden. The Anglican cathedral can be seen from the side window. Staff recall that this room was furnished in pretty green and pink floral fabric. Here are stored many personal items, including their clothing, toiletries and their love letters and cards, which were carefully sorted and numbered by Chambré Hardman.

The Bathroom
The Hardmans' bathroom still retains its 1930s bath and fittings.

Top The Hardmans' cluttered Kitchen

Above The Bathroom sink

Right The Kitchen today

Opposite The Kitchen draining rack photographed by Hardman (140034)

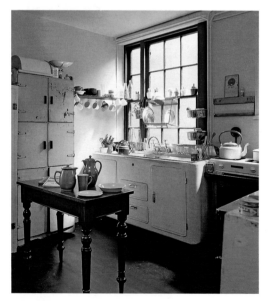

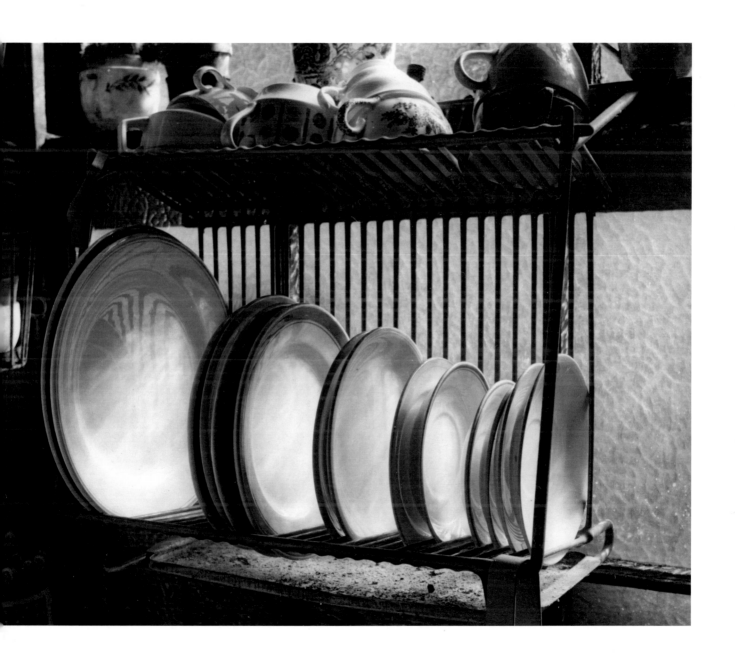

Please return through the living quarters and down the stairs to the ground floor, and turn left. Under the stairs is the door to the Cellar. The Cellar steps are steep, and if you would rather not venture down to the Cellar, carry on to the Exhibition at the back of the house.

The Cellar

This cramped and cluttered space was used for processing and developing negatives and loading the exposed plates, as well as for storage. The lead-lined sinks and rows of hanging negatives, drying in the cool air, can be seen amongst the chemical bottles and equipment.

The Exhibition and Office / Work Space

This room is where the telephone was located, so appointments were most likely made here. It also served as a place for storing paperwork to be sorted out and was quite

Above Hardman's hat hangs in the Cellar Lobby

Right Hardman took great care with the mounting of his photographs

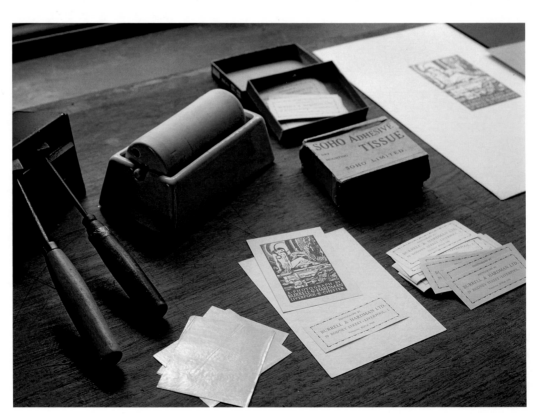

chaotic by all accounts. Today there is a changing exhibition on aspects of the collection and the Hardmans' life.

The Retouching and Finishing Room

At the desk by the window the negatives would be retouched and the final prints finished. Retouching involved working on the half-plate negative with a fine lead pencil applied to the oil or 'medium', which completely covered the surface of the negative. This would enable spots, unwanted hairs and wrinkles to be covered and blended with the background. Finishing the print could involve scraping in highlights with a fine knife or toning in with paint and a very fine brush. This room was also used by staff to hang their coats and eat their sandwiches. It was as chaotic as the living quarters.

The Mounting Office

This room was used for mounting proofs and prints, as well as recording and invoicing orders. Framing was generally carried out by an outside firm, Blackburn's of Wood Street. On the desk you can see the large iron, gas-fired press, a guillotine for trimming edges, and various tools. This area was kept immaculately clean to avoid spoiling the prints. The drawers opposite house envelopes containing information about the hair and eye colour of clients. All the necessary equipment for dispatching the prints is also seen here.

The Garden

The rear garden is typical of its time, with common plants in borders with a paved area and a bird bath. Although the Hardmans had very little time to garden, they set up here a sculpture by Herbert Tyson Smith, a leading Liverpool sculptor and friend, whose work can also be seen in the Anglican cathedral.

The Garage

Now used for visitor reception, this once housed the Hardmans' Daimler, which took them on many photographic trips into the countryside.

Top The back garden

Above and left A 1954 portrait photograph of the actress Patricia Routledge before and after retouching (140029, 120213)

EDWARD FITZMAURICE CHAMBRÉ HARDMAN

Childhood

Chambré Hardman was brought up in Ireland. He adopted his unusual middle name Chambré (which was a family name on his mother's side) to distinguish himself from his father, Edward Townley William Hardman, a land agent in Co. Dublin. He was the third of four children and the only son.

First steps in phtography

Chambré Hardman remembered his introduction to photography as a child: 'I was encouraged by my father who was a keen amateur and took pleasure in photographing the family and their pets as well as making use of photography for recording land tenures.' He also recalled how his 'first negatives were made using father's quarter-plate brass and mahogany Lancaster stand camera, and how the exposed glass plates were processed in the wine cellar and contact prints made in the apple loft.'

Service in the Indian Army

'An awful place, no trees, stones on the hills and no level ground, nothing to do and every chance of getting shot' (from a letter to his sister).

Following family tradition, Chambré Hardman served in the Indian Army from 1918 as a regular officer in the Gurkha Rifles. Stationed on the infamous North-West Frontier, he was inspired by the beautiful landscapes of India, and refused to be deterred by the difficult conditions. He worked first with a Kodak No.3 special camera using quarter-plate negatives, then with a new Sanderson tropical camera, which became his favourite in this period. He continued to use this camera throughout his life, especially for architectural photography.

It was during this time that Chambré met and became good friends with Captain Kenneth Burrell, whose home was in Liverpool. Together, they made the important decision to set up a portrait studio on their return to England, where Chambré Hardman would take the pictures and Burrell would look after the business. They arranged for passage to Liverpool, trusting to a new life in a new country.

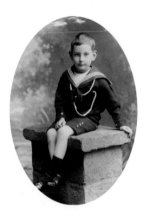

Above Edward Chambré Hardman about 1906 (120124)

Right The 2nd Battalion, Gurkha Rifles in India about 1920. Hardman is in the back row, second from the right. His future colleague Kenneth Burrell is standing fourth from the left (140006)

Opposite This atmospheric view of India was taken by Hardman about 1922 and is one of the earliest images in the collection

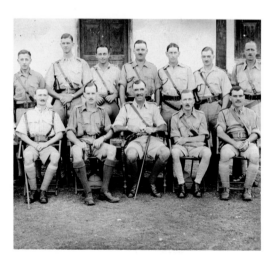

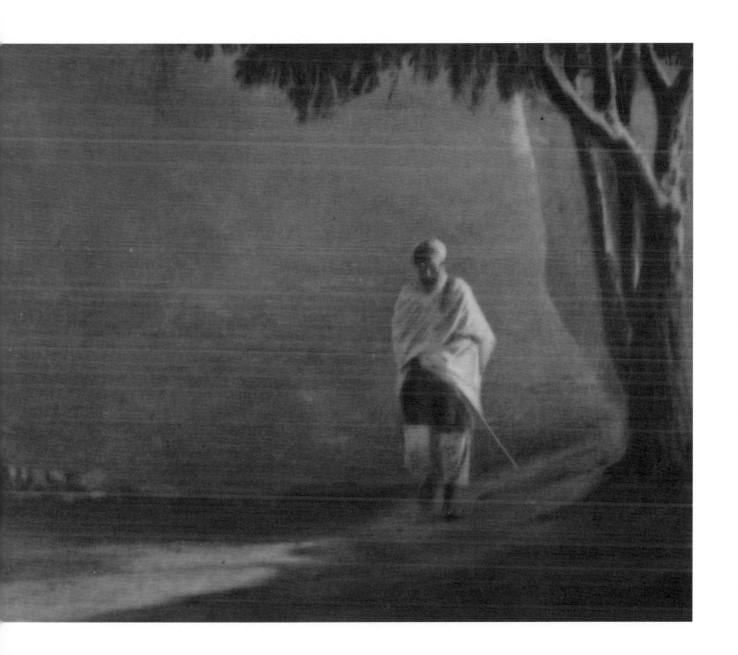

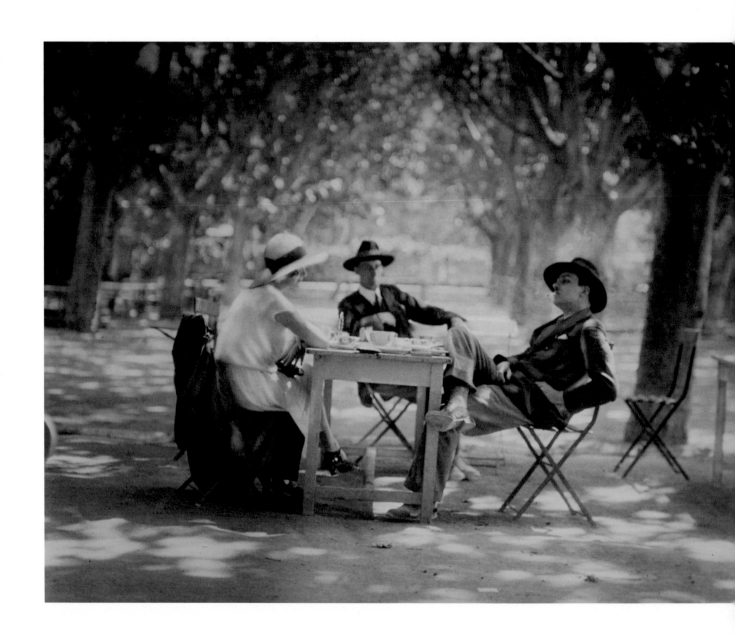

ESTABLISHING THE BUSINESS ON BOLD STREET

In March 1923 Burrell and Chambré Hardman moved their studio to the first floor of No. 51 Bold Street, one of the most prestigious commercial thoroughfares in Liverpool. They succeeded in attracting a number of important sitters, including the Earl of Derby and Professors Patrick Abercrombie and Charles Reilly of the University of Liverpool. In spite of these welcome commissions, the business took time to establish, and in the first year Hardman was selling and repairing wireless sets to subsidise the studio. His confidence grew, however: in 1925 he joined the London-based Royal Photographic Society, and in the same year had two portraits accepted for exhibition, a sign of his growing recognition amongst his peers. He exhibited there regularly until well after he retired.

In 1929 Kenneth Burrell decided to leave Liverpool. From then on, Chambré Hardman ran the business with the help of studio assistants. He retained the name Burrell & Hardman, and remained friendly with Kenneth Burrell for the rest of his life.

The Sandon Studios Society
An important source of artistic and professional sustenance for Hardman at this time was the Sandon Studios Society, which he joined in 1923. Located in the Bluecoat School, Liverpool, the Sandon Society was the major social focus for Liverpool artists.

Hardman described how he 'became intimately acquainted with a circle of practising architects, painters, sculptors and musicians'. Burrell & Hardman became the photographers of fashionable choice, and it was said that 'it was more or less obligatory for anyone on Merseyside with any pretension to distinction to be photographed by them'. Many of Hardman's sitters became his friends, and he would holiday and work with key members of the society for some time to come. In the summer of 1926, for example, he toured Provence with fellow Sandon member, the architect Harold Hinchcliffe Davies, and his wife Norah. Here he made a number of photographs, including *An old Frenchman* and *A Memory of Avignon*.

'I came across this old man, who seemed to be hundreds of years old, in Martigues a couple of years ago. Realising the pictorial possibilities I succeeded in inducing him to pose for me, and the exposure was made while he sat on a bench in the shade of some trees. A beam of direct sunlight was used to give a backlit effect' (110027)

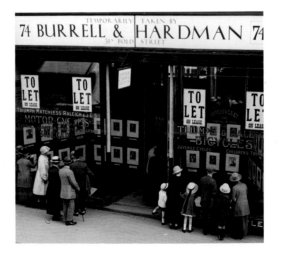

Left Burrell & Hardman rented window space in 74 Bold Street. Their studio was at No. 51a (140009)

Opposite A Memory of Avignon, 1926 (110002)

ETHEL MARGARET MILLS (1908–70)

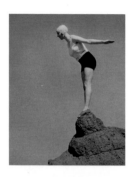

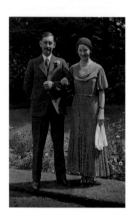

Top The Diver, 1929. Margaret posed for this photograph (110221)

Above Edward Chambré and Margaret on their wedding day in 1932 (140035)

Opposite Margaret photographed by her husband on Loch Eriboll in northern Scotland (140037)

Margaret Mills joined the staff of Burrell & Hardman in 1926 as an assistant. She was newly graduated from the Liverpool Institute, and was an aspiring portrait photographer. She was unusually competent, vivacious and had a good head for business. Soon she was looking after the studio in Chambré Hardman's absence. The frequent letters between them, often written in the third person and using nicknames, reveal how they supported each other in their work and express how much they missed and loved one other. However, financial and career issues, and Chambré's concerns about supporting his mother, shadowed their relationship, and in 1929 she left the business to join a firm in Paisley, Scotland. 'My big reason for coming away,' she wrote, 'was because of [you]. Pearl [i.e. Margaret] was taking his mind off his work and since she's come away he's done some topping things – and got his name and B & H better known' (Margaret to Hardman, 16 October 1930).

Her departure hit him hard: 'The light has gone out of his life,' he wrote, 'because she has turned her face away from him. You make things worthwhile for me, now nothing seems worth doing' (Hardman to Margaret, 17 June 1929). They would meet often in Scotland, their letters revealing a tentative but growing preoccupation with the possibility of marriage and a business life together. 'We would be a success together, I know, and dearest we have had three years to test our love…. It wouldn't cost much to

rig up a children's studio would it? … Please think hard and tell me if you really want me to join you' (Margaret, 21 July 1930).

Chambré Hardman took numerous photographs of Margaret during these years, in particular a portrait in a swimming costume called *The Diver*, which was first published in the *Manchester Guardian*. Eventually, on 10 August 1932, they married at Rainhill parish church, Lancashire, and honeymooned in Switzerland with friends.

They did not have children, but always seemed to have a dog for company, and went on holiday to take photographs, whenever the portrait work allowed. They explored Scotland and Wales, the Lake District and Yorkshire, initially by bicycle and train and then in their Daimler. They later moved to a house called 'Three Stacks' in Barnston, on the Wirral peninsula, designed by Hardman's Sandon Society friend F. X. Velarde. They lived there for nine years until their move to 59 Rodney Street.

Margaret is remembered fondly by the studio assistants, who recall that it was she who ran the business. She set high standards, but also took an interest in their lives. She called Chambré 'Hardie' and chided him often in their company. He was the quiet one, whom they all respected, while she was the sparky one. They remember how the couple worked tirelessly together on their shared passion, photography. Chambré acknowledged that he 'could not have done it without her'.

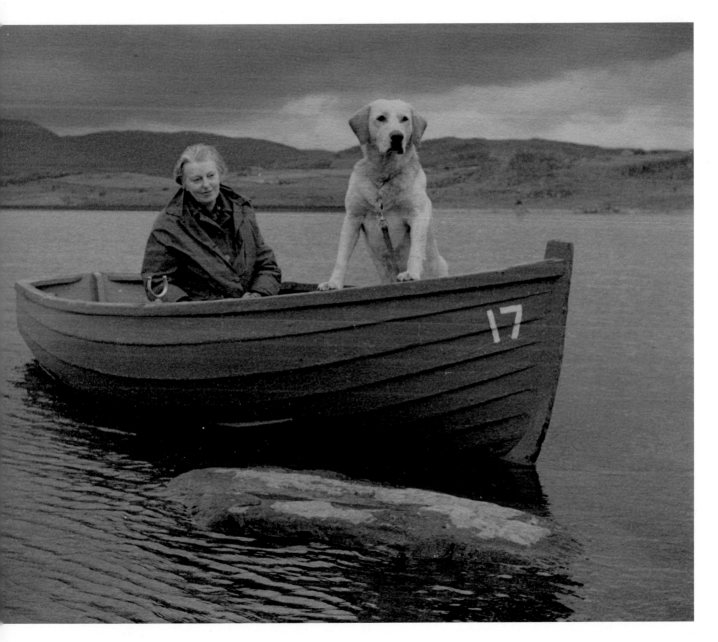

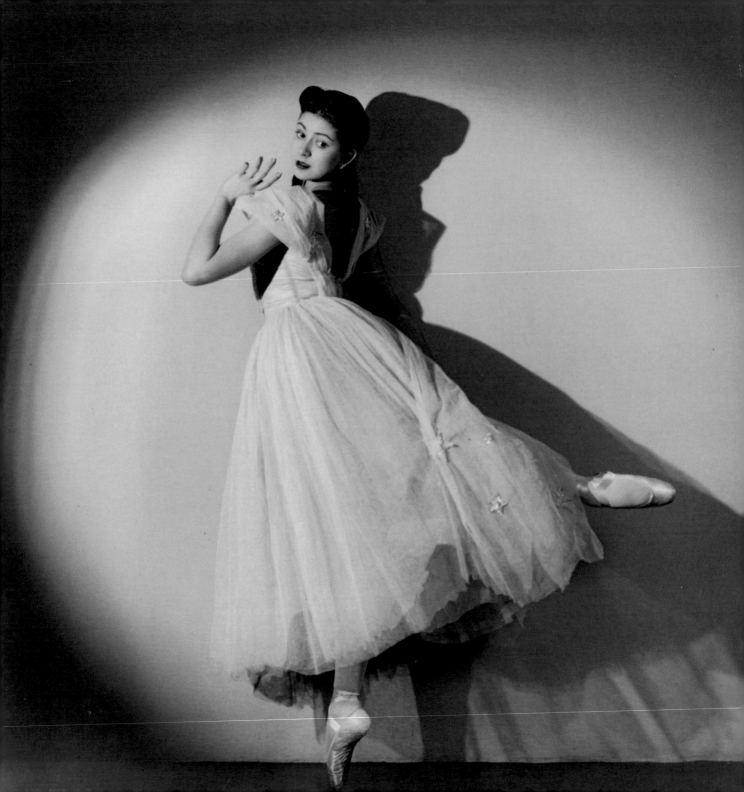

PORTRAITS IN DEMAND

When asked who, among his famous clients, proved to be an easy sitter, Chambré Hardman recalled that 'one easy famous sitter was [the composer] Ivor Novello. His face was his fortune and he knew how to exploit it. He knew which angle he looked the best. In fact he only liked one side – his right profile – and you will rarely see him captured at any other angle…. He was a gift to photograph.'

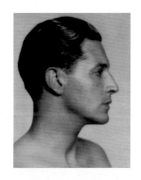

The business prospered, and in 1938 Hardman took over the lease of a second portrait studio at 27 St Werburgh Street, Chester. For the next 20 years the company traded as 'Burrell & Hardman, Liverpool & Chester'. Hardman's status and that of the business had grown: sitters included the ballerina Margot Fonteyn.

The outbreak of war in 1939 caused practical difficulties for the business, but also stimulated demand, as Hardman remembers:

The lack of photographic supplies in the war helped us really. Amateurs simply couldn't get them, so demand for professional work increased…. We were very busy indeed during the war, as Liverpool was full of Army, Navy and Air Force personnel, Americans and Canadians, all wanting a picture in uniform.

During the war no fewer than 1,747,505 service personnel passed through Liverpool's docks on their way to and from war. Many of these servicemen and women were keen to have a portrait photograph for their families, boosting Hardman's business. The appointment book for 1941 showed six or more sitters per day, and eight for Christmas Eve, while the staff had grown to fourteen or fifteen in number. The contribution of portrait photography to wartime morale was officially recognised through its status as a 'reserved occupation' of national importance. Hardman remembered how 'I received many letters, almost pathetic in their gratitude from those who had sustained loss and who considered the portrait I had taken to be their most precious possession.'

By 1947 the Liverpool studio was producing publicity photographs for the Liverpool Playhouse. The demand continued.

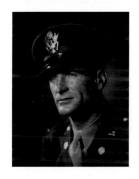

Moving to Rodney Street

The end of the lease on the Bold Street studio brought about a move to 59 Rodney Street. Chambré and Margaret sold their house in Barnston in June 1949 and bought the property on Rodney Street, where they both lived and ran the business. Here they employed ten assistants and had an annual turnover of £3,800. Situated in an area mixing smart residences with the offices of medical consultants and architects, the new premises marked a rise in status. The business prospered. They also continued to run their Chester studio until 1959.

Top Ivor Novello in 1929 (120048)

Above Lieutenant Chambers in 1944. During World War II Hardman photographed numerous American servicemen as they passed through Liverpool (120208)

Opposite Margot Fonteyn in 1939 (120206)

DRAWING IN LIGHT

Pictorialism and a love of landscape

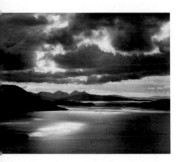

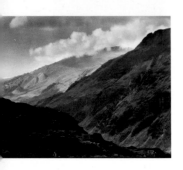

Landscapes were Chambré Hardman's passion from childhood onwards. In later years he described 'one particular aspect which appeals strongly to me; the open, spacious view in our own homeland'. 'In a pastoral or cultivated landscape … every lane, every field, every hedgerow is eloquent of man's association with and dependence on the soil.' His continued trips in pursuit of landscape photographs, even during wartime, and afterwards into his 70s, demonstrate this passion, as does the legacy of images he has left us.

Chambré Hardman's aesthetic stance on photography, and his technique, are described in his own notes, lectures, published articles and teachings. He took a 'pictorialist' approach to his work, be it a portrait, building or landscape. He would very carefully compose his subject to minimise the work needed in the dark room, on the negative and in developing the final print. Having made best use of the light, arrangement of subject and camera angle, he would produce an enlarged negative, to give the opportunity of lightening and darkening areas before printing.

Having taken the photograph, he would not hesitate to improve the image: 'I have no hesitation in using any means of control, at any stage which will help to give me the result I want, providing it does not conflict with the photographic quality of the image.'

He used the technique of pencil and dye retouching, employing a red dye called Coccine Nouvelle to disguise blemishes ('carbuncles', as he called them) or toning areas to balance the light and the dark so as to create the desired effect. He found this particularly useful in landscape photography, as he described in the *Camera* magazine of July 1931: 'In landscape work it is the supreme process for introducing atmospheric perspective by throwing back distant planes, for emphasising clouds and for creating accents.'

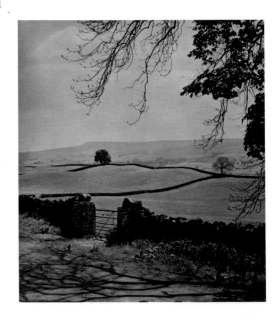

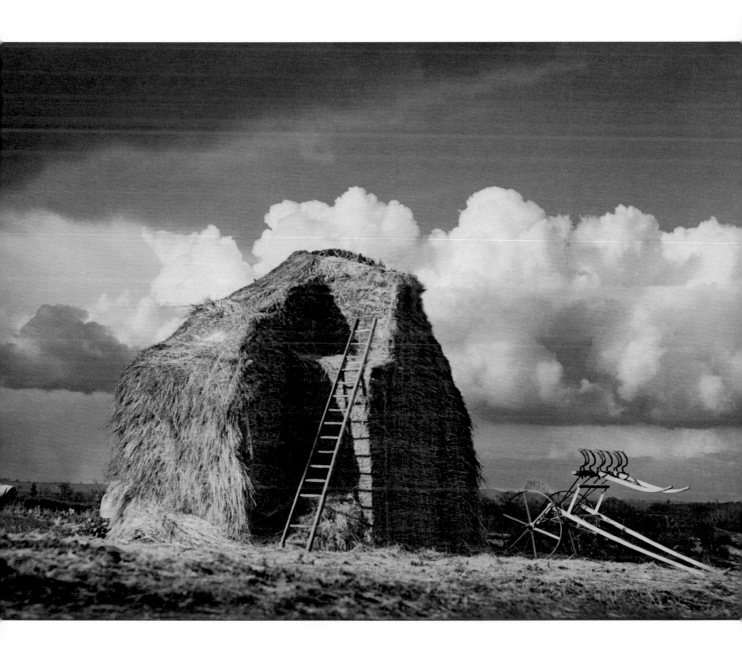

LIVERPOOL

The growth of a city

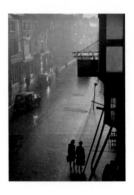

At the beginning of the 20th century, Liverpool still vied with Glasgow for the title 'Second City of the Empire'. Rows of substantial houses, like those in Rodney Street, had been built to house the merchant and professional élite, second only to those of London. The magnificent industrial, commercial, civic and domestic architecture of Liverpool is a testament to the city's confident and innovative spirit in this period. Chambré Hardman captured something of this mood in his photographs. Some were commissioned as part of his work as a leading photographer of industry and commerce.

For example, he took publicity photographs for the Cunard magazine, Martins Bank and the British Insulated Callender Cabling Company, as well as publishing in the *Liverpool Post* and *Mercury*. He also captured street scenes such as Little Howard Street, Central Station and views of the Anglican cathedral and the museum steps.

'Control by patience'
The Birth of the Ark Royal, 1950

Chambré Hardman spotted the *Ark Royal* on the horizon on an April day in 1950. She was freshly painted white in preparation for her launch by the Queen Mother, framed by the cranes and a foreground of suburban houses. The ship 'stood out like a ghost, it looked monstrous in size'. In a BBC recording, he described how he captured the image and then altered the negative, by toning down the gable of the house and removing small blemishes and cropping the image to improve the balance and composition. Hardman's method of waiting for the right moment, and then attending to the composition, and altering the tone of elements within it – 'control by patience' – produced outstanding work of this kind. *The Birth of the Ark Royal* has also become Hardman's most reproduced photograph, encapsulating an era in Liverpool's industrial history that has gone for ever.

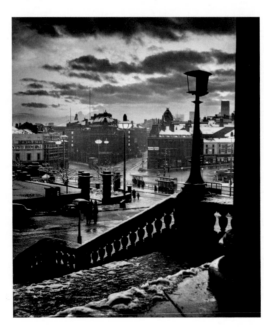

Above Rainy Day in Chester, 1952 (110423)

Right Museum Steps, 1946 (110018)

Opposite The Birth of the Ark Royal, 1950 (110001)

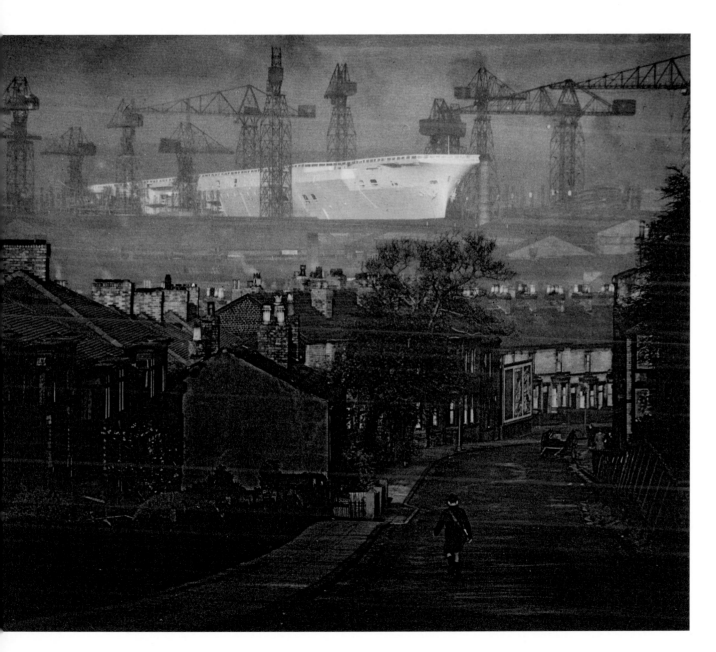

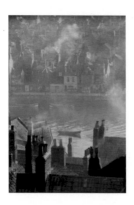

In 1951 the prestige of the firm had never been higher, but in cash-strapped post-war Britain business was difficult. Chambré Hardman applied for several jobs in the following years, starting with a post of Senior Lecturer in Photography at the Guildford School. In a letter to his referee he confides:

Life has not been easy for the last three years … it is for my wife's sake I apply for this post …. By hard work we have increased the number of sitters in 1951 by 18% over 1950 and by 30% over 1949 but most sitters spend less money than was the case three years ago.

Above Whitby, *c.*1949
(110511)

Right Hardman
photographed in the Rodney
Street Waiting Room by
Peter Hagerty in the 1980s
(140032)

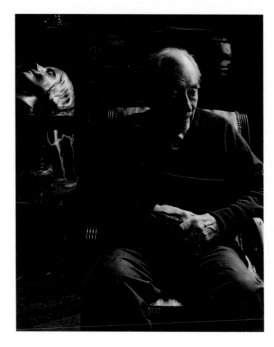

Despite these pressures, he and Margaret continued to make and exhibit landscape photographs. Chambré Hardman also continued to write about and teach photography, particularly pictorial work. Their passion for landscape photography never declined. When asked 'what has it brought you?', he replied:

It hasn't brought me wealth but it has brought me a great interest…. My eyes were opened by photography over the years. I am always looking for a subject. People might consider it a humdrum subject – a back street or a wonderful light; something like that…. Every sitter has a problem to solve, every landscape a good moment and a bad moment…. There is always a good subject to be dealt with.

The ECHT and the National Trust

Chambré Hardman retired in 1965, and his health declined in later years. After a fall in 1979, Social Services put Peter Hagerty, Director of the Open Eye Gallery, in touch with him. Realising the significance of Chambré Hardman and his work, Peter helped Chambré to safeguard his collection and establish the E. Chambré Hardman Trust (ECHT). The ECHT worked tirelessly to preserve the collection, and with the help of others, came together with the Liverpool City Council, the National Museum of Film and Photography and the National Trust to save both the premises and the collection for all to enjoy.